wet

ALSO BY LEANNE DUNIC

The Gift

*One and Half of You**

To Love the Coming End

* Published by Talonbooks

wet

leanne dunic

Talonbooks

Talonbooks
9259 Shaughnessy Street, Vancouver, British Columbia, Canada v6p 6r4
talonbooks.com

Talonbooks is located on xʷməθkʷəy̓əm, Sḵwx̱wú7mesh, and səlilwətał Lands.

First printing: 2024

Typeset in Arno
Printed and bound in Canada on 100% post-consumer recycled paper

Cover design and cover photograph by Leanne Dunic

Talonbooks acknowledges the financial support of the Canada Council for the Arts, the Government of Canada through the Canada Book Fund, and the Province of British Columbia through the British Columbia Arts Council and the Book Publishing Tax Credit.

Library and Archives Canada Cataloguing in Publication

Title: Wet : poems / Leanne Dunic.
Names: Dunic, Leanne, author.
Identifiers: Canadiana 20230571719 | ISBN 9781772016048 (softcover)
Classification: LCC PS8607.U535 W48 2024 | DDC C811/.6—dc23

to the beings I love

In this hemisphere, it's the rainy season but water refuses to fall. Neighbouring forest fires in Indonesia taint the sky with stormless clouds.

Last summer, the Pacific Northwest's trees crisped like matchsticks. I seem to have brought the weather with me.

In these conditions, is the snail still slick enough to glide?

In Kalimantan, can the gibbon, the frog, the loris, and the mongoose outrun slash-and-burn?

A day of auditions and wandering lost in this city-island-state. Nearly a hundred dollars in cab fare spent for a chance at work. I changed into flip-flops after the last go-see and now my tote is heavy with heels, water bottle, and portfolio.

Pigeons coo under a shop canopy. I mistake a police siren for a wailing man. Wings flap and decay.

Hot oil, sweet almond. A trace of sewage.

Anxiety, an eddy inside my chest.

Of the over three hundred species of pigeons, fifteen of them live in Singapore. The most prevalent is the rock dove. It's highly adaptable and can be found all over the world – like me.

An arts degree isn't sustaining me (you were right, Ma!), but modelling erodes its consequential debt.

I'm too old to share a room. Twenty-four is likely too old to model, too.

When I worked in Shanghai last year, the model I shared bunk beds with screamed into her pillow every night. She suggested I try it. She had been modelling for years.

Now, an extra four hundred dollars is deducted from my earnings each month so I can sleep alone. Luxury living.

An air-conditioning unit hangs over my single mattress. Opposite mine, another bed without sheets. I brush a dead moth from my pillowcase, smearing its shimmering essence on the cotton. Above, water rushes through pipes. An echo from the stairwell – someone clipping their nails.

In Shanghai, the apartments were so cold that I slept in my winter boots and coat, with my hat and scarf draped over my face. I awoke to cockroaches scuttling along the kitchen counter.

Here, I wake up with a sweaty sheen and ants in the kitchen.

The view, a cotton-batten sky. Visibility, two blocks. Below, a gouged-out urban hole. A metal dragon lowers a slat, then another, in a slow game of Tetris. Migrant workers wear canary-coloured hard hats and boots, towels around necks, torn fabric for masks.

I share this flat with a fifteen-year-old model from Poland and one from Russia who is the same age as me. A domestic helper from China sleeps on a futon behind the living-room bookcase. None of us talk much. I asked the Russian girl,

Why do we have a maid?

<div align="right">

The last one ran away
even though
the agency had her passport.

</div>

Sometimes the other models and I go to the same auditions together. They've been here longer and can navigate.

From the trees, primitive cries. A monkey? Bird? The call quickens. Ahwoooo. Ahwooo. Ahwoo.

The last time I saw rain was on my taxi ride to Sea-Tac Airport.

Drops fell among sunbeams.

A rainbow arched. Somewhere.

Fluorescent-orange netting sections-off walkways around the condo construction site – the kind found on oceanic garbage islands strangling seabirds and turtles.

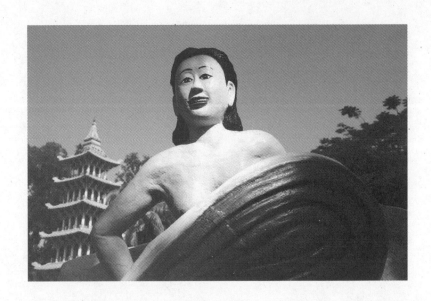

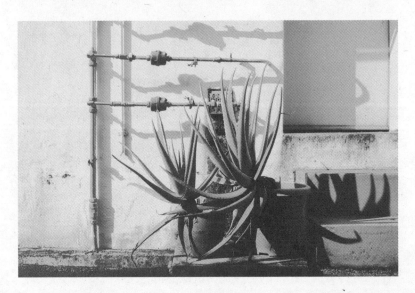

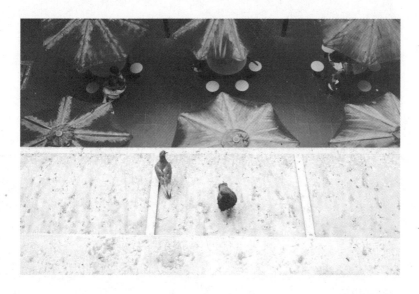

I grab a coffee and bun from a hip café and notice the absence of tip jars, think about the burrito joint in Ballard with the handmade sign: *Mark got shot. Let's help him with his medical bills!*

Next door, a shop sells goldfish and turtles festering in plastic bags. I buy an ice cream sandwich from the stall at my housing estate. Lap the quickly melting vanilla edge. Smooth. Layer after layer.

I pass three construction workers washing their hands in a bucket of grey water. Make eye contact with one. I look away. Look back. He does not smile, eyes fixed on me.

I wasn't *born* a worker.

Small puddles form on the ground as the men clean themselves. Pigeons drink the water.

The men producing the ESPN commercial give me their phone numbers and offer to show this American-born Chinese girl around Singapore. I'm not supposed to fraternize with clients, but my body wants to ignore my mind.

Sometimes I take the bus rather than the MRT so that I can map this world I've fallen into. CCTV watches from points A to B. Cameras are everywhere once you notice them.

I've watched men stretch prata dough behind hot grills on North Bridge Road, wandered the crowded clothing stalls at Bugis, explored the temples on Serangoon Road. On Sundays, I stroll Little India to see the boys hold hands and wonder why men in other cultures aren't as free to share their affections with one another.

Also in Little India, I watched a man cry as he was taken away by police.

Like they do every weekend, the American and Australian models are going to Kuala Lumpur to party. They didn't invite me. I wouldn't go anyway. Don't they know the effect of drugs and booze on their skin?

The girls in my apartment are here to pay eighteen percent to our agency, to send money home, to save for an escape. I'm here to make triple what I made serving in Ballard.

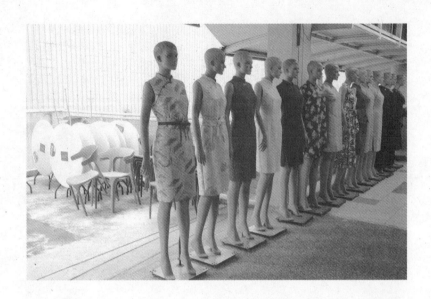

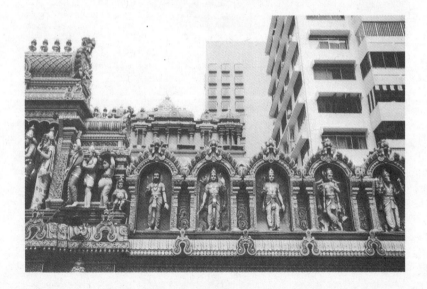

My cousin told me about Mao's campaign during the Great Leap Forward to kill the four pests: flies, rats, mosquitoes, sparrows. The people banged pots incessantly to prevent sparrows from resting. Soft stones dropped from the sky.

What other animals fell?

Fifty-five million people. My ancestors.

In this block, poisoned bread is left on the sidewalk for pigeons. For cats. For dogs. The hungry.

As she kneads my foot, my masseuse asks me where I'm from. I
return the question. Her: Sabah, Malaysia. Speaks English, Tagalog,
and Bahasa Melayu. I'm surprised by her strength. She's twenty. I'm
only four years older, but weak and basically monolingual.

<div align="right">

Want fifteen minutes body?
Ten dollars only.

</div>

She guides me to a bed. Clothes on, face down. She hoists her whole
self on top of me. Presses her rigid fingers along my body, thrusting
them just outside of my . Her fingers ream me through the
stiff denim of my shorts until she claps palms on my back and says,

<div align="right">

Okay.

</div>

And now I'm helpless with want.

Dream of stuffing envelopes. White envelope after white envelope, nothing inside but my fist.

Models must stay hydrated, eat non-greasy food, no chocolate. Exercise regularly. The agency stresses the importance of staying fair. Use whitening cream and an umbrella when walking under sun. I don't always abide by these rules.

At the food centre, I cool down with grass jelly and soy milk. A stall serves pork only cut from the underarm (since the area sees little sun, it's extra tender). I order wanton mee.

It takes nearly an hour to get from downtown to the flat. There, I watch a clip from back home: a disabled sow gets an acupressure massage from a volunteer at an animal sanctuary.

I burst from sleep, chest throbbing as if actually blown apart by a gunshot.

Resonance. My ribcage trembles for hours.

I read from a collection of reimagined fairy tales and hope for a different kind of dream.

These solitary days on the mountain helped Snow White realize just how much she had missed living in a wild world. *A mountain?* the prince had asked. *Why would you leave the castle? Anything you want, you can have.* As she stared out the window of her new cabin at the snow-quiet landscape, she knew she had made the best decision.

I'm perched on a stool as a young man applies my makeup. The bristles of his brush on my eyelid trigger a reflex of tears. He sighs.

Why you so sensitive?
Your crying is wrecking the liner.

I'm not crying.

Tears lah.

Sorry.

I should cry.

Got to ride back to JB tonight.

Malaysia?

Mmhmm. Every day.

Too expensive to stay here.

At my last casting:

 Why not give me your number?

And earlier, my agent:

 Why you act so old?

Other models:

 Why don't you want to go clubbing?
 Everything free for models!

Why why why?

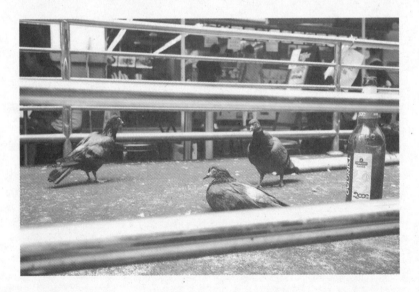

On the way to an audition, a faint voice behind me says,

<div align="right">Miss?</div>

I turn around. A man stands timidly a few feet away from me. He points to himself.

<div align="right">Me. Tamil.
India person.
No work.</div>

I know I only have ten dollars. And that I need it for my lunch today. Surely he needs it, too.

I hand him a two-dollar bill, hoping I'll get this job and that next time I can give more.

As I walk to the MRT station, I pass temple walls watered to cool.
A careful fire crafted inside. Men adorn the colours of flames, clutch
branches of neem. To prove their faith, their soles press embers.
Thousands walk. Heat into skin, into vein and bone. Feet cool in
goat's milk, turmeric dust.

On the curbside a devotee raises his arm, heat still in his calves.

Each taxi passes him.

The ad director calls me into his office. Early forties, he sits in his chair with legs open.

How do you like Singapore?

Too hot.

That's why there's AC.

Bumps rise on my arm.

I know many people.

I could get you higher-paying gigs.

How about I take you to dinner?

A call from my agency.

You got the job.

Great!

I wonder if it's because the director asked me out.

He did?

Unacceptable!

I lose the job.

Guess I won't report misbehaviour in the future.

The palm's leaves are singed from late-summer offerings in the container beneath them.

Pigeons crowd the altar, gorge on tributes of baked goods and fruit.

Please donate for the upkeep of the people.

I misread. *Temple.* Not *people.*

A rat runs across the sidewalk, then back again. He looks in my direction and runs towards me. I casually step to the side as the rat continues into the bushes. This is how I make friends.

A masked girl draws a stick through thin ash along the bank of the algaed river. Watching over her is a man, brown-skinned and slender, his hair like the black of volcanic rock.

Tiny fingers take mine. Maybe she's mixed? She lifts her mask to reveal a smirk. Her hand in mine, a comfort.

The lanky man scolds her in Mandarin.

Méi shì, I say. It's okay.

The girl takes his hand to hold us both in her palms. The man and I look at each other, smiling. I don't want to let go of the link to her father, but the intimacy overwhelms. I retract my hand.

The man says something in Mandarin I don't catch.

I open my mouth, wanting language I'm unable to find.

He grins and tries again in English,

Where are you from?

America.

You?

Bangladesh.

Pigeons dip their short beaks in the water.

A huntress knocked on Snow's door. From a faded, snow-dusted sack, the woman presented Snow with a welcoming gift of apples, persimmons, and pomegranates.

Snow couldn't guess the huntress's age. She had a prominent nose and her hair was dark with a slight auburn tint. She smelled faintly of soil, musk, and animal blood. Snow had a fondness for hunters, since one had spared her life.

The agency provides membership to a gym at HarbourFront where I pay fifty dollars a month for a locker so that I don't have to carry my workout gear between jobs and auditions.

The sixteenth-floor gym looks out to Sentosa Island on one side and Mount Faber on the other. Compared to the mountains back home, Mount Faber looks like a glorified hill. I prefer to use the machines that overlook the shining sea.

I like it at the gym because I never have to wait for a shower and the stalls are clean and roomy. Sometimes I see my Russian roommate here, but she exclusively hangs out with other Russian girls and only gives me a nod.

Mirror, Mirror on the wall … I lean in to inspect my skin. It seems thicker, the pores larger. My eyes look dull. Need more sleep. More water. My next gig is in two hours at the Singapore Recreation Club. The air is bad today but I can't wear a mask, or I'll get lines on my face.

I use a tissue to wipe away a bead of moisture at the corner of my eye. My hands scoop cold water from beneath the tap and I drink.

At the juice bar in VivoCity, I order an "Energizer" with wheat grass.
A quick blast of nutrients between jobs.

A middle-aged Chinese man approaches me.

<div style="text-align: right">Can I be your friend?</div>

I narrow my brows and look past him to the crowds of people
shuffling by with shopping bags.

I mumble,
No thank you.

I recall the Bangladeshi man. I would've liked to have been his friend.

I think his daughter wanted that, too. I can still conjure the feeling of
her small hand in mine. How my breath quickened when I caught her
father's eye.

A singer from Tainan takes the stage. She wears a polka-dot dress.
Between songs she banters about the haze affecting her voice. She says,

Birthdays are not a celebration.

She tilts her bobbed head, wonders aloud why she was born, why she
will die. Is it her birthday today?

She and I both know we are flotsam.

I chew the straw in my drink. With my mind's eye, I send her an
image: an oceanic cave, tepid water. An invitation.

Blood pounding, I approach and tell her I love her voice. She asks my
favourite singer. I show her photos on my phone of Neil Finn.

Ah, Crowded House.

We grin and laugh. I'm surprised she knows of him.

I've used the extent of my Mandarin. Our conversation ends and I
return to my stool.

I imagine the singer's moon-milk skin.
Slough a summer of skin.
My contracts, searching for a handhold.

The dead watch you at every moment.

And this is what you do?

Synonyms:

sheath
vagina
pussy
vulva
hole
lady parts
cunt
snatch
twat
genitals
beaver
box
honeypot
conch
muff
cooter
sex
crotch
WAP
slit
fanny
privates
pudenda
vag
bits
vajayjay
kitty
downstairs
flower
peony
cooch
nothing ...

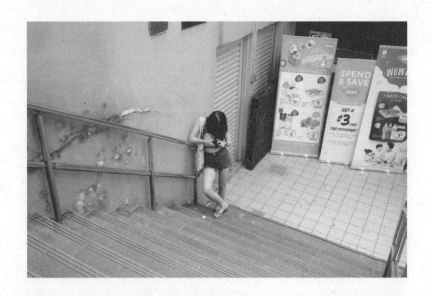

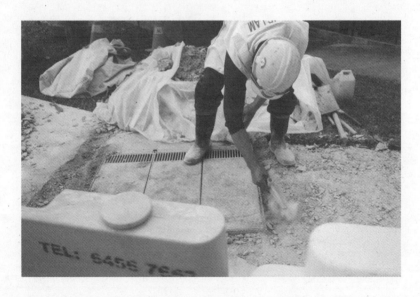

The door of the second bedroom is ajar. Inside, bunk beds. Suitcases flush with the wall. Fruity perfume. Lying on the pillow of the top bunk is a stuffed rabbit.

The smell of ammonia stings my nose. A line of ants climbs along the counter. The helper flattens them with her thumb. The young model winces with each squish.

Maybe the ants are just cleaning up our mess?

Neither the helper nor the young model says a word.

Women pull at my inner thighs to fit me into their shapewear. They talk around me. Do they think I don't understand because of my American accent?

Naughty girl shaves her chibai.

Once absorbed into the nude-coloured, body-shaping undergarment, I walk the show with other size 0 models. My shoes are too small but I smile and sashay in this unsightly underwear like I'm fucking Cinderella.

Or like I need the five hundred dollars.

Best not to let anyone into your cabin, the prince
admonished her before she left. Despite that, Snow
invited the huntress inside, then washed and sliced
some of the fruit. The woman took an apple slice off
the plate and motioned for Snow to have some. Snow
knew she shouldn't, but she couldn't help herself.
The apple was crisp and moist and delicious.

Snow told the woman how she came to this mountain to
see red foxes. She hadn't seen one before and, after two
days, still hadn't. In fact, she hadn't seen any animals at all.

The woman nodded. "You'll see one soon."

Snow hoped she was right.

The huntress ate a few more apple
slices before heading off.

Hold the tube in your left hand.

Smile!

Now say, "I can't believe how white my teeth are!"

Run your hand along the toothpaste.

And ... wink!

Train station at dusk. Hundreds of birds in trees. This urban space in their migratory path. A mania.

No rain, but thousands of litres of high-pressured water clean these roads each night.

If this equatorial summer is over, why do fires continue?

I'm sitting in the makeup chair, butt clenched. Food poisoning? I'm grateful this isn't a show because I certainly wouldn't be able to walk with confidence. Still, how can I look good when I have a fever and might explode out either end?

I towel my face, smudging my makeup and frustrating the crew. I want to yell, I don't want to be here! But I persist, sending silent prayers to the deities of Pepto Bismol.

This time, my masseuse looks to be my popo's age.
She takes me to the bed and pulls the curtain around us.

Clothes off.

She doesn't leave.

I strip to my underwear.

Those, too.

I hesitate.

We all girls.

I do what I'm told. I have the respect-your-elders/be-a-good-girl
gene.

In the stairwell, I sneeze. I ask the man armed with a canister,

What are you killing, Uncle?

Without looking at me he says,

 Cockroaches. Bugs.

What'll the lizards eat?

 Always more bugs.

Nature is failing. She burns and burns, forgetting what it feels like to be wet.

And me. Weathering. A salted cup, waiting for damp.

Nearby forests scorch. Not a sky-born drop, yet water pours from faucets. I only shower when I have to. Bathroom tiles like Chiclets. Under a layer of eggshell paint, a line of ants embalmed. The helper cleans the bathroom twice a day.

Cats wail in the alley.

Should I leave a dish of water out for animals? Or will that only breed mosquitoes? Who gets to survive?

Fires consume bodies.

We wear white masks to filter toxic breaths.

No shade today. Pollutant index high.

Hammers, drills, engines. Chink of chains, hooked and linked.
Insertion of rods. Hollow metal. Pegs and piping. Language.

Fill hole fill hole fill hole fill hole fill hole
fill hole fill hole fill hole fill hole fill hole
fillholefillhole

Out the window, Snow was surprised to see the white landscape had started to melt. Perhaps now animals would emerge. As she scanned the snow for movement, she was startled by a thunk at her window.

A bird lay on the ledge outside, unmoving, its feathers a surprising bouquet of sunset colours. Snow opened the window and collected the bird with cupped hands. It was so beautiful and warm. She pressed the bird to her cheek, as if to keep its life from leaving its body. Its head flopped back and a drop of blood emerged from its beak. Snow brought its tiny chest to her ear. The heartbeat ceased.

Snow's tears surged. How badly she wanted to be close to animals, to have them love her as she loved them. Perhaps she should never wish for anything again.

A makeup artist is at the studio when I arrive, but leaves me alone with the photographer when she's done.

He shoots me draped on a black couch and against a bright red wall. After about half an hour, he passes me a handbag and asks me to take my shirt off.

You can hold the bag in front.

My body goes cold. I don't want to take my shirt off here alone with this man. I tell him no. With a chuckle, he tries to convince me, as if I'm being silly for saying no. Am I?

Would my roommates have done the same thing?

I ask for my money and leave. Once I'm wrapped in humidity, I notice my hands are trembling.

I pass a hand-sized lizard on its back, flattened stiff. The line of its mouth, a dry smile.

Not even reptiles can survive this drought.

In my heart, I hold all the moist creatures who burned in the Pacific Northwest this summer.

I walk by a windowless van. A frantic cooing of pigeons. A man stands beside the van's opened back doors and reaches into a large white bucket. He turns to the birds. Empties his palms, a rush of seeds. Frenzy. As I pass, he bows slightly.

I'm sorry.

Why be sorry?

Was he poisoning or feeding the birds?

By the entrance to the convenience store, a girl about my age melts an ice cream bar between sticky lips.

Overheard, an old show tune:

... kehta hu mai sach bilkul
nothing is impossible...

A woman behind the counter searches the mane of her companion, carefully extracts each pewter strand.

I buy bananas, granola bars, and two bottles of H-TWO-O isotonic drink.

On the radio: 1,800 of the city's residents are centenarians.

The ice cream girl returns to buy another – a small tub of Ben & Jerry's Strawberry Cheesecake. I linger to see if she'll immediately dive into this one and, of course, she does.

On the radio: 1,801 on the Pollutant Standards Index in Central Kalimantan.

Let me see your palms.

So lucky, ah!
Why you here? You already psychic.
See? Line of intuition.
I not going to tell you what you don't know already.

But knowing doesn't mean doing, so I'll tell you this:
Don't wear black.

Such a busy body, you be active until death.
You may migrate. Travelling good for you.

A crowd puller but
someone always despise you.

Money comes,
goes quickly.
You want the fattest, juiciest watermelon
and for two dollars.

Manja! Always want men around your finger, lah.

Do not let your body get cold. Do not sleep on concrete.
Do not wash your hair before bed.

You can only do what you love.

You want to be complete.
You good at solving other people's problems, but yours ...

Is it going to rain?

It has to.

Below, a child stomps on the plastic walkway set up around the construction site. As if unaware of her weight, she throws herself against the temporary railing. It does not break as I expect it to. The girl squeals, lifts the front of her shirt up to her shoulders. Only I am watching.

I believed my mother was an honest person. She worked the same job at the electronic shop until it closed two years ago. Some nights she didn't come home and none of us said anything about it.

I tell people I model because I need the money. It's a truth, and it's a lie.

The truth is, when I was a kid I couldn't stand the smell of cantaloupe and now I can't get enough of it.

The truth: I think I'm a monster.

A cat in the stairwell offers its belly. I crouch to pet. The creature
rumbles like a soft motor.

That's Mushroom.

I turn to see Strawberry Cheesecake.

Is Mushroom yours?

No.
But I gave her a cute name anyway.

I've seen you at the shop downstairs.
You like ice cream.

Who doesn't?

Have you had one yet today?

Doesn't mean I can't have another.

Strawberry Cheesecake has lived on this block her entire life, save for a gap year in Melbourne.

At the shop, she also picks up a bottle of water, says she's scared to drink anything else.

But water here is drinkable.

> No, it
> makes my
> stomach
> sick.

I don't know how to respond. Limitless water in stores, but not for the fires. I buy a Magnum bar with almonds and imagine what might've been made with all the plastic we must've tossed in our lifetime.

Strawberry Cheesecake and I stand at the edge of our building's rooftop. Someone has brought up some potted plants. Possibly the same person set up the clothesline that bisects the space.

I sink a finger into the soil of one of the plants and it's surprisingly damp. The colour of the soil isn't far off from the colour of the air.

Dusk can't dull the shine of Strawberry Cheesecake's lips.

Have you seen *The Assault of the Present on the Rest of Time*?

Afraid not.

It's German.
It made me make films.

I think you'd like it.

What are your films about?

Immateriality,
time, ghosts.

I like the way you think.

This is the first time I've come to the rooftop.

I haven't been up for years.

Do you like living in America?

Do you like living in Singapore?

Do people here own guns?

Probably not?

I had a screening in Detroit.
The person I stayed with said,
This fence encloses the property –
so someone can't hop in from the
street.
And I thought
I want to be surprised
– if you have the audacity to break in
and by chance we meet
I want to make it worth your time.

Strawberry Cheesecake pulls out a bag of Pocky. I decline her offer.

How can you eat so much sugar?

She shoves two in her mouth like walrus tusks.

I've been watching those workers daily.
Look at them load themselves into the back of that truck.
Hope they've got a good place to rest.
Doubt they do, though.

 Wish I had a daily grind.
 It appeals because I have
 the luxury
 of thinking about my
 existence too much.

 The workers sleep in crammed dorms.

Ah, Singapore, so prosperous!
Takes care of its citizens
But not the people who take care of it.

Ooh look at Marina Bay Sands. So fancy, lah.
City of the future.
Such deception.

My friends say,
"You have it all
I wish I were you."

Are they really your friends?

Well, you understand the emptiness.

What would we do if we had it all?

I don't care about the five Cs
nor do I have them.

The what?

Typical Singaporean stuff.
Cash, car, condo, credit card –

Clothes?

No –
Maybe it's country club?
I dunno.
As I said, I don't care.
But people do.

I got a dozen mosquito bites yesterday.
Am I going to get dengue?

Where were you?

Arab Street.

You'll be fine.
It's only in certain areas.
Mainly rich people's houses.
With their water gardens and soaked lawns.

Strawberry Cheesecake fingers the nylon line, the faded plastic pegs.

Look at all those window lights around us.

The ceiling fans, the dining
tables ... make me feel cold.

Millions within these buildings, each burrowed
in our dens. Different classes, dialects, desires.
All hungry.

I remember being
on a trip with my ex.
Morning light streamed
through the window.
He was asleep in my arms
and still
I was empty.

Alone, I went on a boat tour
through thousand-year-old caves.
There everything caught up with me.

I couldn't stop crying.

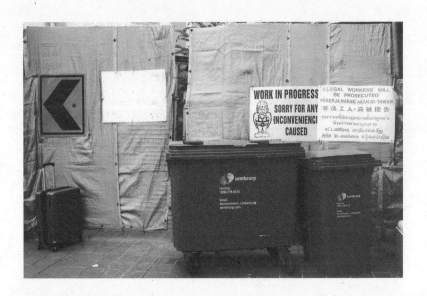

A person shouldn't have to sleep behind a living-room bookshelf.

A fifteen-year-old shouldn't be "dating" someone in their thirties.

I shouldn't have to flirt with men my father's age to get a gig to sell people stuff they don't need.

Why do we put up with such things?

And these people working on this high-rise –

I have the option of going home if I want to. Do these men? Do my roommates?

Dear Pigeon,

Your body is a rain-filled cloud. Two strips of night band each wing.
The aurora of your neck must magnetize you to earth.

Why are you so anxious?

You've made maps, but the city changes.

You're famished, but the bread you've eaten crumbles your bones.

I wash my face of toxins with foam cleanser. Apply toner, then cream that repels free radicals. Pop placenta pills. The skin around my eyes is sheer, clay in colour, thin cracks beneath.

I've stopped using air con – only a fan. Stopped wearing underwear too, tricking my body into believing that it will fuck soon. Self-deception.

New word learned today: aestivation.

From Wikipedia:

> Invertebrate and vertebrate animals are known to enter this state to avoid damage from high temperatures and the risk of desiccation ... To seal the opening to their shell to prevent water loss, pulmonate land snails secrete a membrane of dried mucus called an epiphragm.

It's nearly 11 p.m. and men still work below.

Fall asleep to a gentle buzz and pop, small insect bodies against glass.

As I leave the block, I spot a tailless lizard on the stairs. I cup my palms around the tiny, translucent creature. In an attempt to pick it up and move it away from the poison, I crush its yielding skull with my fingers.

The body is lighter than a nickel. I place it at the roots of a rain tree.

I run into Strawberry Cheesecake at the convenience store.

A pigeon flies into the store. People protest, waving their arms, poking their canes.

Oh! What an ugly bird!

I have always been envious of the pigeon's iridescent necklace. I inch towards it, arms outstretched, but it flaps noisily and ascends.

Strawberry Cheesecake and I walk a few blocks to a bench under an angsana tree. She's finished her ice cream. Applies gloss to her already sticky lips. I'm surprised she isn't wearing a mask. Her arms antennae to discover her surroundings. She picks up seed pods and arranges a mandala on the bench.

 Why did you try to capture the bird?

 Isn't it full of diseases?

I'd wash my hands.

Strawberry Cheesecake shakes her head.

Have you tried boiling tap water to drink?

I couldn't be bothered.

She reapplies plum-coloured gloss. The pond of her mouth, an illusion.

Want some? It's caramel-flavoured.

I cough.

Overheard, two uncles in the park:

... because they compete for food,
water, territory.

Do you know about NEWater?

I guess not?

It's water made from pee.

Is that what you're drinking?

No. But one *could*.
It's cleaner than bottled water.
Apparently.

Every molecule is cleaned.

Before they go to all that effort,
maybe they should dump
the pee on the burning forests?

There's a creature I hear all the time
sounds like it's winding up. There's a crescendo
then it repeats.
I'm trying to figure out what it's called.

 Is it a black bird with red eyes?

Haven't seen it, only heard it.
Sounds like it's having an orgasm.

 Never thought of it that way before
 but now that's all I'll hear.
 Thanks.

 In the next life
 I want to be an octopus.

 What about you?

I'd somehow join you in the ocean.

Is the inside of your nose burning, too?

We should probably go inside.
I think the air is affecting my heart
and my lungs.

Shortly after the bird's death, a scratch
sounded at Snow's front door. She peered
out the window but didn't see anything.

Zzrh zzrh zzrh.

She opened the door. "Oh, I hoped
I'd see you again," Snow said.

The huntress let herself in. Her eyes
darted to each wall of the cabin.

"Should I put on some tea?" Snow
asked, pointing to the kettle.

The woman nodded.

The agency texts us to say auditions are suspended until the haze lifts. It's too dangerous to be outdoors. That's obvious. My hair smells like smoke every time I go outside.

But this doesn't help my make-money-fast scheme, which hasn't been going as well as I had hoped. Maybe my Asian face isn't fresh enough here. Maybe I'm too old for this.

At least I have my own room, and I'm happy to read and watch movies on my laptop. What will the other models do?

Another morning. City, citizens, haze. Seattle-grey sky, without the rain. Is this what the end of the world looks like?

I lean on the windowsill. A man sings while he pushes a wheelbarrow. A group of men wash their boots with a hose. One washes his face. No one looks up.

The dragon's arm dangles a rusted chain, a hook, a bundle of tubes. It's a different operator today, the rise and descent of materials faster than before. I try to catch the dragon's eye but it does not wink.

I scan pedestrians for a dark, thin figure. If I spot one, my breath halts until I realize it's not him.

I claw mosquito bites on my inner thighs. The scratching hurts but satisfies.

Again, the mysterious creature bellows from a tree. Husky whistles, faster and faster, rising in pitch.

A masked Strawberry Cheesecake brings me a gift of homemade dessert.

It's cooling.

Has collagen. Good for skin.

What's in it?

Longans, honey.
You soak peach sap in water overnight.
It plumps to three times its size.

Bouncy and soft on the tongue.

Before the haze, we models were rarely all at home at the same time –
working, working out, or staying cool in a mall.

I should socialize with the others. We've all got ideas about one
another but haven't transcended our shyness. I propose that we watch
the latest Peter Jackson flick together in the dominant language, but
they decline. Instead, the three of us congregate in our tiny living
room (where the internet is best), headphones plugged into laptops.

Should we be wearing masks indoors, too? I have gotten used to the smell of smoke and can't tell if the air quality inside is poor.

I watch a local TV program about raising autistic children and cringe with each use of "normal."

The helper is at another job, though I'm not sure what she does. I just know she looks exhausted when she returns to her futon behind the bookcase.

The helper carries in a few brightly coloured packages and places them somewhere behind the bookshelf. At the foot of my door, some of the same – Korean face masks. Pearl Essence. Collagen Boost. Jeju Volcanic Ash.

I ask the helper where the masks came from. She faces the other bedroom, and at the same time, the Russian model walks out. The helper points at her vigorously with a big grin on her face.

Thanks for these.

We all smile.

From rusty earth, a starburst of tree roots and a pile of broken pipes. Two workers remove stumps. Difficult to pile more than two rootstocks into the wheelbarrow, the renegade limbs won't fit together. One worker stands beside the wheelbarrow, two-litre bottle in hand. The other prods the dead wood with a metal rod. One worker holds a bundle taut, the other hacks pieces off.

Today the Polish girl is leaving. She's going to work in Italy. I wonder what her so-called boyfriend thinks about that. I hope she gets the new beginning she surely wants.

A girl from Brazil will take over her bunk in a few days.

The haze only slows the machine.

Somewhere, there must be fecund lagoons and marshes. Here, earth erodes, dust from dirt, gaze into haze. She is solemn, skilled at holding her breath.

Strawberry Cheesecake texts to tell me that the creature I hear every morning is a bird – a koel. They toss eggs out from other bird nests, replacing them with their own.

Cats fight on the fire escape. I feel the vibrations from their bodies as they tumble. A shriek, a thunk. Cries from below.

Flies fuck on my knee.

As Snow prepared the kettle, the huntress moved stealthily from corner to corner, sniffing. Finally, she approached Snow, grabbed her hand, and brought her fingers to her nostrils. Her eyes widened. She got down on all fours and extended her nose as if to trace a scent. Her nose moved through the air, towards Snow's desk. When she spotted the bird, she grabbed it, opened her jaws, and swallowed it all at once.

"My bird!" Snow dropped the kettle onto the floor.

"Not yours," the huntress said. "The bird belongs to the mountain." She scurried towards Snow, saliva running down her now-furry chin. "And now you belong, too."

At Cold Storage, I see him.

Too enthusiastically, I say Hi!

Softly, with a smile, he says,

<div style="text-align:right">

Hey.
I'm Ahmed.

</div>

He offers his hand. I take it.
I try not to let go, but somehow it happens.

His smile lines are like tributaries. Hair rises from my moist skin. I
don't look in his basket because I don't want to appear invasive. But
I am. I want to feel more than his hand against me.

Is your daughter at school?

<div style="text-align:right">

Schools are closed because of haze.
She's at home.

</div>

With your wife?

<div style="text-align:right">

Yes.

</div>

What I really want to ask is

Do you want to fuck *me*?

Will you smother my breasts with your hands, fill and spill?

Water cycle.

With him I could slake my thirst, fill my .

But my good-girl gene keeps me in check. What can I possibly do?

> You're a model, aren't you?

I blush.

How'd you guess?

> You're tall.
> And you always look nice.

Always?
Has he seen me any other time besides that moment by the river?
And when I've been searching for him since?

Snow stared into the fox's golden eyes to see a carnal glint that made something stir within her.

The bird had only whetted the fox's appetite. She licked the side of her muzzle.

I don't know how long I'll stay in Singapore with this haze
and it's too hot and I hate modelling but I don't know what
else to do right now but let me give you my phone number.
You don't have to do anything with it. But then you have it.
And whatever you want, you can make it happen.

No, don't give me yours. I tend to be determined
and I don't know what I'm capable of, what I can
resist. I'll let that be up to you.

Ahmed's image is a ghost against me.

I dream of him holding flame and tongue. Lips wet disgrace. Curve the salty spring. Slightly ridged surface, a dimple yields the spongy resistance of soil. Teeth and tongue to scrape, to get as close as possible without drowning.

I'd surrender these impure breaths for the drink.

6:15 a.m.: Cars. The sky a smoke-spoiled blue.

Skeletal silhouettes stand in the quiet of night. My reflection on the window imposes on the frame of the sleeping steel crane. Is the glow on the horizon from city or sun?

"Blue Sky Mine" plays in my head. Who's going to save us?

I suck on a candy I'll consider breakfast. I lean against the window, watch the street below. For someone.

Fill hole
Fill hole
Fill hole
Fill hole
Fill hole
Fill hole
Fill hole
Fill hole
Fill hole
Fill hole
Fill hole
Fill hole
Fill hole
Fill hole
Fill hole
Fill hole
Fill hole
Fill hole
Fill hole
Fill hole
Fill hole
Fill hole
Fill hole
Fill hole
Fill hole
Fill hole
Fill hole
Fill hole
Fill hole
Fill hole
Fill hole
Fill hole
Fill hole
Fill hole
Fill hole
Fill hole

I imagine Ahmed in a perpetual state of becoming serpent, with no hands to grasp, a poison head. Tonguing me in flickering rhythms, an upward wave, a swell, a twist, a corkscrew constrictor.

We slide to satiate.

Jawbones, luxate to swallow and then – a spell, a spasmodic slough.

His moult in my mouth
and mine
in his.

A colonial urge to mount him.

Sticky fingers feed until fed. Lips part and widen. Breathless, my form travels dimensions.

This ghost parts legs to pass through flesh, a light prick of cells.

Different rules of nature apply. Everything goes in
borders are open open
open.

An upheaval of earth where a sidewalk will soon be. Disappointed I missed the drainage pipe installation and now the soil is levelled and I will never know how such things work.

I did learn that these workers earn less than twenty dollars a day. Most owe thousands of dollars borrowed to come here for this "opportunity."

The form of the future structure matures.

Builders lunch: brown paper makes a plate for rice and gravy. Bare nutrition. Pigeons bob at their feet.

I wonder what brought Ahmed to Singapore.

The fan moves air around my sticky skin. Construction noise unrelenting.

Slam! Slam! Slam! Imagine it's me.

The rattling plow stops. My ears, my – empty.

I try to nap but a new gyration starts. Hums.

Fillholefillholefillholefillholefillholefillholefillholefillholefill
holefillholefillholefillholefillholefillholefillholefillholefillhole
fillholefillholefillholefillholefillholefillholefillholefillholefill
holefillholefillholefillholefillholefillholefillholefillholefillhole
fillholefillholefillholefillholefillholefillholefillholefillholefill
fillholefillholefillholefillholefill

humans fucking humans

In imagination –
in reality –
we are many things.

All that we try to contain.

Fillholefillholefillholefillholefillholefillholefillholefillholefill
holefillholefillholefillholefillholefillholefillholefillholefillhole
fillholefillholefillholefillholefillholefillholefillholefillholefill
holefillholefillholefillholefillholefillholefillholefillholefillhole
fillholefillholefillholefillholefillholefillholefillholefillholefill
holefillholefillholefillholefillholefillholefillholefillholefillhole
fillholefillholefillholefillholefillholefillholefillholefillholefill
holefillholefillholefillholefillholefillholefillholefillholefillhole
fillholefillholefillholefillholefillholefillholefillholefillholefill
holefillholefillholefillholefillholefillholefillholefillholefillhole
fillholefillholefillholefillholefillholefillholefillholefillholefill
holefillholefillholefillholefillholefillholefillholefillholefillhole
fillholefillholefillholefillholefillholefillholefillholefillholefill
holefillholefillholefillholefillholefillholefillholefillholefillhole
fillholefillholefillholefillholefillholefillholefillholefillholefill
holefillholefillholefillholefillholefillholefillholefillholefillhole
fillholefillholefillholefillholefillholefillholefillholefillholefill
holefillholefillholefillholefillholefillholefillholefillholefillhole
fillholefillholefillholefillholefillholefillholefillholefillholefill
holefillholefillholefillholefillholefillholefillholefillholefillhole
fillholefillholefillholefillholefillholefillholefillholefillholefill
holefillholefillholefillholefillholefillholefillholefillholefillhole
fillholefillholefillholefillholefillholefillholefillholefillholefill
holefillholefillholefillholefillholefillholefillholefillholefillhole
fillholefillholefillholefillholefillholefillholefillholefillholefill
holefillholefillholefillholefillholefillholefillholefillholefillhole
fillholefillholefillholefillholefillholefillholefillholefillholefill
holefillholefillholefillholefillholefillholefillholefillholefillhole
fillholefillholefillholefillholefillholefillholefillholefillholefill
holefillholefillholefillholefillholefillholefillholefillholefillhole
fillholefillholefillholefillholefillholefillholefillholefillholefill
holefillholefillholefillholefillholefillholefillholefillholefillhole
fillholefillholefillholefillholefillholefillholefillholefillholefill
holefillholefillholefillholefillholefillholefillholefillholefillhole
fillholefillholefillholefillholefillholefillholefillholefillholefill
holefillholefillholefillholefillholefillholefillholefillholefillhole
fillholefillholefillholefillholefillholefillholefillholefillholefill –

10:23 a.m.: A builder carries a metal sheet above his head, flashing shards of sunlight.

Edge of autumn, here it is endless summer. Pearl-hued particulate. Sightlines obscured. Diminishing palms.

Like gold-and-vermillion insects, builders scurry. They cart trash, transfer beams, assemble scaffolds. Metal cicadas.

Wet concrete pours onto the gravel perimeter from a suspended piping bag. Two men level aggregate, one more skilled.

6:35 p.m.: The crane lights up. Insects swarm the illumination.

I've stopped wearing clothes. I throw on a dress when I have to pee or eat. My hair looks amazing but there's no one to see it. Can't remember when I washed it last.

The construction noise has stopped for a moment. The furthest thing I can hear: cars. The closest: breath streaming through my nose. I move my focus between the parts like a meditation until the sound of metal breaking pavement resumes.

Wake to the call of the koel. This sole bird commands a vast area. Touch my to the rhythm of its pulse.

Sun reflects onto one building. That light shines onto another. The buildings appear to lean towards each other. An illusion of wanting.

A flutter in my lungs. Each inhale a hazed breath. Dust and blood in my handkerchief. The city has sold out of masks.

Outside, the sound of metal smashing metal. Heat index in the low forties. Workers wear long sleeves and cloths to protect their necks, their faces black with dust and sun.

Everyone else, preserved indoors.

Two months of this acrid haze. I order KN95 masks from Taiwan. How many to buy?

One hundred silver packages in a cardboard box. Masks with a flexible metal edge to form against nose and cheekbone. My tote full, I walk downstairs to the site. The perimeter squared in by metal barriers. Above the awning, sheets with "Sound Barrier" printed on them. A provisional enclosure. I don't know how to be noticed. I place the masks in a pile by the orange netting.

From my window, I wave good morning to the construction site. A masked worker holds a hand to his forehead.

I pause, spread fingers on glass. The distance between, the width of the street.

As close as we'll get.

5:15 a.m.: The whoop of the koel wakes me. As the bird hits its climax, another chimes in, a perfect pulsed harmony.

The building site is dark save for the street light. Detect two stars, each with an opalescent aura.

With a smile, Snow stepped closer to the fox.

"Your tail looks so soft. May I touch it?"

The fox nodded.

I run my hands over all of the plants outside Strawberry Cheesecake's
flat and find the fleshy leaf of an aloe. Without thinking, I snap
the thickest arm at its base. Moisture oozes from the aloe leaf and
my mouth waters instinctively. I peel the outer skin to reveal the
succulent's pith.

Tiny bubbles are visible in its gel. I toy the chunk in my fingers,
crushing cells to release wet molecules.

<div align="right">

If you want
you can have a plant.
I have lots.

</div>

I'm mesmerized by the drip at the edge of the leaf.

I scoop a portion of gel onto my palm to admire its clarity.

Strawberry Cheesecake presses into the plant's wound. I do, too.
We slather our forearms, our legs, our faces with its gel.

 I want to eat the jelly!

Yeah, but I heard that it's bitter.

I catch Strawberry Cheesecake's eye.

We bring jellied fingertips to our tongues. Upon contact our faces
scrunch. We laugh.

The taste is unpleasant but the moisture is unrivalled.

We bow to the beauty of this wet.

Snow had underestimated the bushiness of the tail, which now curled around her entire body, supporting her head, weaving between her legs, blanketing her torso. The fox's snout traced from Snow's toes along the side of her body and neck. She paused by Snow's ear, hair bristling her skin, and whispered, "You smell damp. Like melted snow."

I can't resist snapping arm after arm from the base of the aloe. The sound and sensation satisfy.

The fluid within satisfies.

Why want for anything else?

I slide slick fingers between lips.

Contained within salted skin, a squall.

Wave upon wave.

Come wind. Come flame.

Curled fingers.

Come, cloudburst.

Come.

Pulled out of me.

Water marked sheets.

 That oceanic feeling.

Snow blushed. She closed her eyes and surrendered
to the spread of red fur that caressed her. She looked
down to her thin feet and watched them deliquesce
– a sensation she had never felt before. Her calves,
then her thighs, spilled into the widening pool.
Inch by inch she dissolved. Snow soon relaxed into
the newfound boundlessness of her body. You may
think that it's a misfortune to melt – even Snow had
seen *The Wizard of Oz* – but becoming part of the
mountain was what Snow wanted above all else.

The fox let the others into the cabin: the deer,
the owl, the shrew, the crane. More followed. The
animals gathered around the crystalline puddle
that was Snow and saw themselves reflected.

They bowed to her and lovingly lapped her up.

The first drops.

Deluge roars. Workers run under a corrugated metal shelter.
No one slips.

My elbows on the windowsill. Watch men watch water fall.

An open window, a moist exhale.

A pigeon preens atop a lamppost.

On the sidewalk, fallen leaves glisten like cockroaches.

Now, my pores can breathe.

I drag through wet grass, leave glistening trails.

Heavy cloud spreads like a lover. A long-lost one. A new one. Eager. Desperate. One you fuck like the first time is the last time. It might be. Trembles above. A groan. Fingers reach upward, wanting to press into the dark and pulse parts to pull liquid from each crevice. A crack, an echoed pleasure. A quiver. Motorcyclists buzz and search for shelter. We all have buried a sense of impending change – not superstition, but frequency in the air. Electromagnetic. Jackhammer. Body flutters. Windows rattle. This hole – my ... wet.

I am agape. This paper is damp.

ACKNOWLEDGMENTS

The writing of this book took place in various locations, mainly on the Ancestral and unceded Territories of the Coast Salish Peoples. Thank you to Grey Projects, where this work found its start, and to New Zealand Pacific Studio, Hypatia-in-the-Woods, Mineral School, The Residency Project, Deer Lake Artists Residency, and the folks at Jack Straw Cultural Center. Much gratitude to Matea, Sarah, and Tom, whose influence took this work where I wanted it to go.

Further gratitude to Madeleine, Merilyn, Kathleen, Eunji, Ruben, Alvin, Will, Eliza, Dawn, Francesca, David, Jessica, and Michelle @ RMIT, Catriona and the Talon family, Karen and The Banff Centre. Dolla, Domo, and PonPon. And Ryan, for all the/my shenanigans.

Thank you to SSHRC, British Columbia Arts Council, and Canada Council for the Arts for support of this project.

Thanks to *LooseLeaf Magazine* and the *Indianapolis Review* for publishing bits of this manuscript, and to Myrna at Expedition Press for letterpressing words from this work.

Please consider supporting the Singaporean organization HOME (Humanitarian Organisation for Migration Economics), who work hard at advocating the rights of migrant workers in Singapore: www.home.org.sg.

An important resource in writing this book was MD Sharif Uddin's book *Stranger to Myself: Diary of a Bangladeshi in Singapore* (Landmark Books, 2017).

LEANNE DUNIC is a multidisciplinary artist. She is the author of trans-media projects such as *To Love the Coming End*, *The Gift*, and *One and Half of You*. The leader of the band The Deep Cove, she teaches fiction and hybrid forms at Simon Fraser University's The Writer's Studio. Leanne lives and relies on the unceded and occupied Traditional Territories of the Sḵwx̱wú7mesh (Squamish), xʷməθkʷəy̓əm (Musqueam), and səlilwətaɬ (Tsleil-Waututh) peoples. www.leannedunic.com.